THE SKATING MINISTER

THE STORY BEHIND THE PAINTING

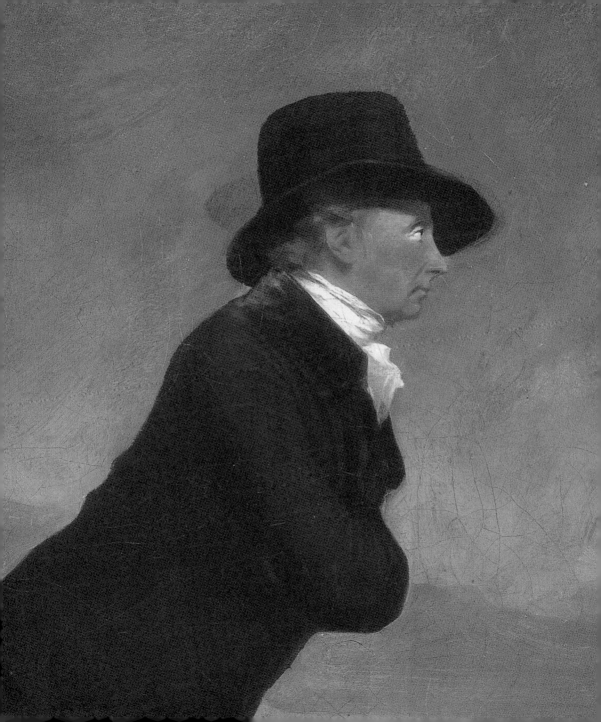

Duncan Thomson
in association with Lynne Gladstone-Millar

— ◆ —

THE SKATING
MINISTER

The Story Behind the Painting

— ◆ —

National Galleries of Scotland
National Museums of Scotland

2004

Published by the National Galleries of Scotland
Dean Gallery · Belford Road · Edinburgh EH4 3DS
— and —
NMS Publishing – a division of NMS Enterprises Limited
National Museums of Scotland · Chambers Street · Edinburgh EH1 1JF
Text © the Trustees of the National Galleries of Scotland
and the Trustees of the National Museums of Scotland

ISBN 1 903278 55 4
ISBN 1 901663 85 X

Designed and typeset by Dalrymple in Monotype Fournier
Colour reproduction by Transcolour, Edinburgh
Printed and bound in Poland by OZGraf S.A.

Cover: Henry Raeburn
The Reverend Robert Walker Skating on Duddingston Loch
National Gallery of Scotland, Edinburgh

FOREWORD

 This book on a Scottish painting that has become famous worldwide is one of the fruits of an ever-closer relationship between the National Galleries of Scotland and the National Museums of Scotland. The Galleries, mainly concerned with the European schools of painting and sculpture, including the Scottish one, and the Museums with a particular concern to place the material culture of Scotland in its wider context, are both dedicated to enhancing the value of their unique collections in ever more accessible ways. In a world that seems to grow smaller by the day, the need to extend the boundaries of understanding only becomes more obvious. This is a quite modest contribution to that aim which we see as being so important. It is the story of a painting that illuminates both an episode in Scottish history and an aspect of the history of Scottish painting, and we hope that it will add to the understanding of something that has already established a hold on the imagination of many throughout the world. We commend it to our readers, both at home and abroad.

SIR TIMOTHY CLIFFORD
Director-General · National Galleries of Scotland

DR GORDON RINTOUL
Director · National Museums of Scotland

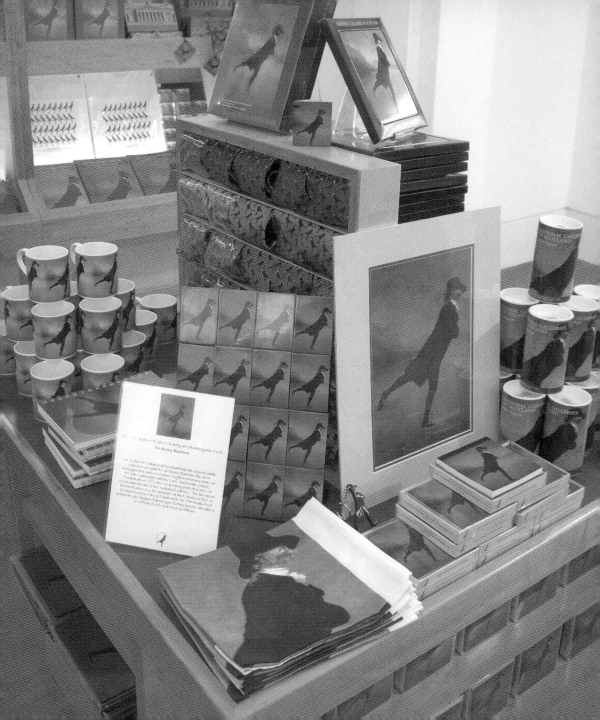

SURPRISED BY FAME

HENRY RAEBURN'S portrait of his friend the Reverend Robert Walker skating on a hard winter's day more than two centuries ago is a painting that anyone with even a passing interest in such things will know something about. It is one of that select number of pictures, like Leonardo's *Mona Lisa* or Edvard Munch's *The Scream*, that is immediately recognisable. The name of the artist or the identity of the finely balanced figure in the black coat may not spring immediately to mind, but the simple image will nearly always provoke a smile of familiarity. There is also a good chance that the picture's everyday title, 'the skating minister', will be pronounced with some satisfaction, part of that feeling of pleasure and affection that the painting inspires.

An important part of the picture's fame is that it is probably based as much on reproductions as on the picture itself. Surrounded by other Scottish paintings of the eighteenth and nineteenth centuries in the National Gallery of Scotland, it is much visited, but the lasting impression is just as likely to have been made by the postcards, mousemats, tea-towels, carrier bags or mugs that are on sale in the Gallery shop. In this way the skating minister is carried around the world. Such indeed is the magic of the image that the Catalan architect, Enric Miralles, transposed the linear dynamics of the figure into the shape of the office windows in Scotland's new Parliament.

left Shopping for the Skating Minister

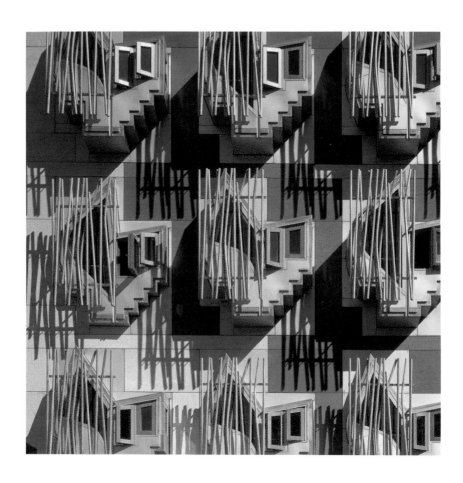

Windows on Scotland's new Parliament building
*The architect Enric Miralles was fascinated by the painting
of Robert Walker and derived his window design from the
silhouette of the skating minister.*

Pictures that have acquired such fame have usually been around for a long time, hanging in public galleries and reproduced many times over in books about the artist. But the strange thing about this picture is that, until as recently as 1949, practically no one knew of its existence. It was not mentioned in any of the early books on Raeburn and never reproduced, even when it appeared briefly at an auction house in London early in 1914. Long hidden from any expert's eye in the houses of the subject's descendants over four generations, this was its first, scarcely noticed, emergence from obscurity – to which it soon returned.

Raeburn painted this portrait, so different from any of his other surviving works, when his reputation as Scotland's pre-eminent portrait painter was already well established. Why he should have painted Robert Walker in such an unconventional way is something we will consider later. When Robert Walker died in 1808, at the age of fifty-three, the painting came into the possession of his widow, Jean Fraser. When Jean died in 1831, it was inherited by their daughter Magdalen, who was married to Richard Scougall, a merchant in Leith. It was subsequently inherited by the daughter of these two, Margaret Scougall, who married James Bairnsfather Scott. In due course it came down to their daughter, the skating minister's great-grand-daughter, Beatrix Scott, who lived in Boscombe in Hampshire. What the various family members thought of this unusual portrait of their ancestor we, unfortunately, do not know. It is likely to have been seen by many others in this period of more than a hundred years, but not a single person appears to have left any record of it. There is only a note that it was seen by a restorer in 1902, which suggests that at least it was being properly cared for.

Then, in March 1914, Beatrix Scott put the painting up for sale at the auction house, Christie's, hoping to get at least 1,000 guineas for it. The early years of the century had been a heyday for Raeburn prices, but times were

changing as rumours of war increased, and the painting failed to find a buyer. In 1926, when the economy was in an even worse condition (it was the year of the General Strike), Beatrix Scott sold the painting privately to a Miss Lucy Hume, of Cavendish Road in Bournemouth, for £700. The picture remained with her until 1949, another time of austerity, when it was once again presented for sale at Christie's. The chairman of Christie's at the time believed the painting would be 'cheap at £1,000'. In the event, on the initiative of the great historian of British art, Ellis Waterhouse, who was then Director of the National Gallery of Scotland, the painting was acquired for the nation – for the modest sum of £525. Christie's had on this occasion included a photograph of the picture in their promotional literature and that is likely to be the first time it had ever been reproduced. It was to be the first of many millions of reproductions in a whole variety of forms. Now, the long dead Presbyterian minister, who clearly loved life, was skating 'into time and history'.

But the picture's fame was not immediate. In 1949, art galleries had a faintly forbidding air, a certain aloofness, and did not go out of their way to publicise their activities. Growing prosperity, however, led to changes in society that brought greater equality and a much wider interest in the culture of the past. Galleries in turn began to sell themselves more vigorously, and while some might now question the new-found reliance on hype and soundbites, the health of society gained from far wider access to the arts. Yet even the process of popularisation was slow; it is a curious fact that as recently as 1972 when the Gallery published a history of its collection, *Pictures for Scotland*, no mention was made of the painting of the skating minister. The slightly sentimental portrait of Mrs Scott Moncrieff still reigned supreme as the archetypal Raeburn.

However, something of the picture's essence caught the eye of the man

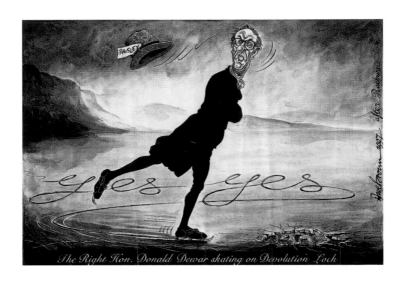

The Right Hon. Donald Dewar skating on Devolution Loch

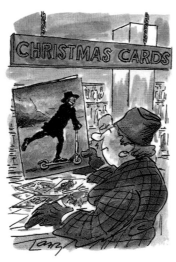

above DAVE BROWN
'The Right Hon. Donald Dewar
Skating on Devolution Loch'
*Devolution for Duddingston — and the
rest of Scotland.*

left TERENCE PARKES ('Larry')
*Larry's cartoons never had captions —
and this certainly didn't need one.*

and woman in the street, perhaps a deep-rooted need for some lively link with the past. Marketability followed as new means of reproduction appeared and in the last two or three decades the picture has become a virtual icon for the National Gallery of Scotland. Indeed, it has become more than that and is now 'the Scottish picture', something so readily identified and so inherently witty that the image is frequently filched by cartoonists, political and otherwise. And, almost inevitably, the painting has come to signify Scotland's greatest painter, as Henry Raeburn's minister friend fluttered on banners in the streets of London when the major exhibition of his work was shown there in 1997. It would have astonished Raeburn, who throughout his life felt rather ignored by the metropolis. And, a final pointer to a fame now wider than Scotland or Great Britain, where the term 'international reputation' really has some meaning, is how the image became the standard bearer for the exhibition of British painting from Hogarth to Turner, *Pintura Británica*, held at the Prado in Madrid in 1998. The city of Velázquez and Goya was suddenly awash with posters of this startling picture from the north.

THE SKATING MINISTER

WHO WAS Raeburn's friend, this Scottish minister who acquired a kind of immortality he could never have expected? Robert Walker was born in the village of Monkton in Ayrshire on 30 April 1755, the third child of the parish minister, William Walker, and Susanna Sturment. Susanna was an American from Virginia, a fact that hints at horizons rather wider than those of this rural backwater. William Walker's manse, where Robert spent his earliest years, no longer stands, but it lay halfway between his own church of St Cuthbert's and the nearby church of St Nicholas in Prestwick where he was also expected to preach. St Cuthbert's is a small pre-Reformation building which remained in use until 1837, after which it fell into disrepair. Its ruins and surrounding graveyard can still be visited.

In 1760, when Robert was five, William Walker was called to the vacancy in the Scottish church in Rotterdam. Here he would minister to a large expatriate congregation of merchants and their families, seamen and mercenaries, as well as the descendants of those who had earlier fled from religious persecution in Scotland. It is more than likely that the Walker family set out across the North Sea from Leith, the port of Edinburgh. Rotterdam was a far greater port. An English contemporary remarked on the complexity of its skyline: 'It would take a degree of divination to tell whether it is a town, a fleet or a forest.' The Scots Kirk, built in 1695 on the south side of the Vasteland at its junction with the Schiedamsedijk, on the the northern

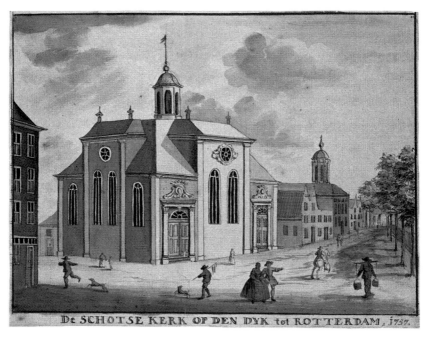

De SCHOTSE KERK OF DEN DYK tot ROTTERDAM, 1757.

J. KOSTER The Scots Kirk in Rotterdam, about 1757
Collection Municipal Archive, Rotterdam

The stone for the decorative parts of the building, which was completed in 1697, was shipped from Scotland. In 1940, German bombs destroyed the church.

bank of the Nieuwe Maas, was an impressive classical building, its frontages pierced by large, round-topped windows. It was built with Dutch bricks, but the pilasters and other details were Scottish stone. This, 2,500 cubic feet of it, had been sent across the North Sea free of charge by a number of the small burghs on the River Forth. Nearby were the Leuvehaven, the oldest part of the harbour, and the Zalmhaven (the 'salmon port'). Still a relatively

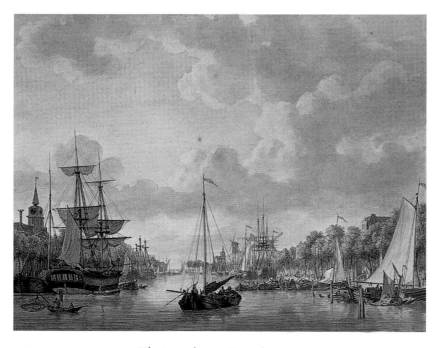

GERRIT GROENEWEGEN The Leuvehaven, Rotterdam, 1795
Collection Municipal Archive, Rotterdam

The oldest harbour in Rotterdam, the Leuvehaven was used by Scottish shipping.
The Scots Kirk, where Robert's father was minister for thirteen years, was nearby.

new building when the Walkers were there, the church was totally destroy-
ed by German bombing soon after the start of World War Two.

It is only possible to guess at the details of the family's sojourn in Rotter-
dam. Robert is likely to have learned Dutch and to have had some awareness
of Holland's embroilment in the Seven Years' War. It must have been
the Dutch side of his character that caused him in adulthood to write his

Observations on the National Character of the Dutch, and the Family Character of the House of Orange. A family event that was probably much more traumatic than his uprooting from Scotland was the death of his mother at some time during their early years in Holland. This was followed in 1767, when he was twelve years old, by the re-marriage of his father to Elizabeth Lawson, the widow of a Rotterdam merchant, William Robertson.

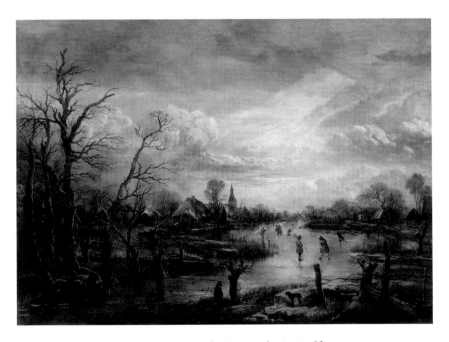

AERT VAN DER NEER Winter Scene with Figures Playing Kolf
The Norton Simon Foundation

Although Kolf was usually played on enclosed courts, a version was often improvised on the frozen canals.

Winters were harder then than now, and the web of canals and waterways that were such a vital part of life in Holland were frequently frozen over. But life went on much as usual, with the everyday activities of commerce and entertainment simply transferred to roadways of thick ice. As paintings and engravings show, many took to skates and Robert must have been among them. This early introduction to the sport and its necessary skills no doubt gave him an edge over his contemporaries in Scotland when he came to join the Edinburgh Skating Society.

He must also have become immersed in the other games played on the ice, particularly those related to what we now call golf. This can be surmised from another of his later writings, *Kolf, a Dutch Game*. This was not a book but a very long footnote written in the 1790s for a friend, the Reverend Alexander Carlyle, minister at Inveresk, for inclusion in his article on the life of his parish for Sir John Sinclair's huge *Statistical Account of Scotland*. It is odd that such prominence was given to this essay for it describes an indoor game played with clubs, balls the size of cricket balls and target posts at either end of a rink, which was sometimes roofed. Calculated ricochets from the low side walls were part of the skill. Although Robert does not mention it, pictorial evidence from the seventeenth century shows that a version of the game was also played on ice. Whatever form it took, it was (and is, for enthusiasts still play it in Holland) very different from the game that Carlyle saw being played on the links of the east coast of Scotland.

It is not surprising, given his background, that Robert should eventually enter the ministry. Both his father and grandfather had done so, and his uncle Robert, minister at the High Kirk of St Giles, was one of the most distinguished churchmen in Edinburgh. It was he who had proposed, albeit somewhat belatedly, his brother William for the vacancy in Rotterdam. In 1771 this Robert was elected moderator of the General Assembly of the

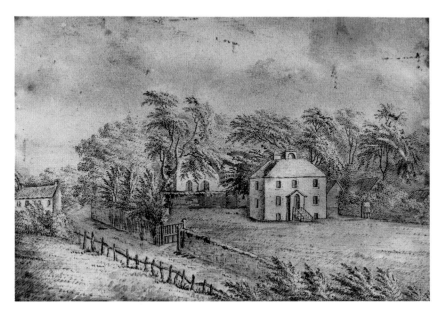

UNKNOWN ARTIST Cramond Manse
Crown Copyright: RCAHMS

This naive little drawing shows a building that has not greatly changed over the years.

Church of Scotland, the church's governing body; and in that same year the younger Robert appears to have matriculated at the University of Edinburgh. The records are inconclusive, but he is likely to be the Robert Walker who attended the philosophy classes of Adam Ferguson, one of the great proponents of the Scottish 'common sense' school of philosophy.

It seems likely that Robert did not bother to graduate, something not all that uncommon at the time. However, by 1776 he was deemed by the presbytery of Edinburgh to be sufficiently well qualified to be inducted to

his first charge. This was to Cramond Kirk in the village of the same name, some six miles north-west of Edinburgh on the shores of the River Forth. At the age of only twenty-one he was being asked to cope with a parish in disarray. The previous minister had left because he had lost faith in the idea of an established church and the lay patron had failed for a number of years to supply the 'elements mony', needed to pay for the wine and bread of the sacrament. In fact, no communion had been administered for five years. In addition, the manse and its outhouses, as well as the school and school-master's house, all the responsibility of the minister and his elders, were in a state of disrepair. Adultery among the parishioners was rife.

Two years after his arrival at Cramond, Robert Walker married Jean Fraser, daughter of an Edinburgh lawyer. She must have found her situation difficult. It is not impossible that Robert sought some relief from the problems of his parish by seeking more congenial society, as well as physical recreation, in his membership of two Edinburgh associations, both, of course, all male. In September 1779 he was elected to that august body, the

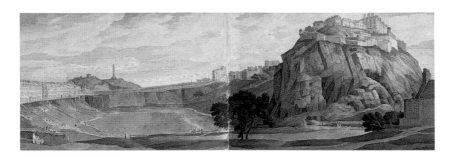

FRANCIS TOWNE Edinburgh Castle and the View towards Calton Hill, 1811
National Gallery of Scotland, Edinburgh

This watercolour shows the houses of Princes Street, on the left.

Royal Company of Archers, later to become the sovereign's bodyguard in Scotland. The following year he joined the Edinburgh Skating Society.

Active membership of these bodies must have entailed long rides into Edinburgh and back, and, since skating was of necessity only possible in severe weather, pursuit of this particular sport involved extra hazards for a rider. In fact, the society's favoured stretch of water, Duddingston Loch, lay on the edge of Duddingston village, which was a further two miles to the south-east of the High Street of Edinburgh. As he rode into the city in these years Robert would have been struck, especially in bright weather, by the sight of the golden buildings of the classical New Town that was rising in the fields to the north of the castle. This development would take another two or three decades to complete, and in the meantime the focus of public affairs still lay in the medieval area of the city, despite its increasing over-crowding and squalor.

The High Street was, and is, like a lizard's skeleton in plan, with its head the castle and its flattened tail the Palace of Holyroodhouse, while its ribs are the narrow streets and closes that fall away to either side. Geologically, it is a 'crag and tail', the castle rock and the debris left by ice travelling over it to the east in pre-historic times. The lower section of this mile-long tail – now called the Royal Mile – was the Canongate, once a separate burgh out-with the city walls which had been founded by the canons of the adjacent Abbey of Holyrood, hence its name. It was to this part of the city that Robert would soon move, attracted no doubt by its social variety – and not by its proximity to Duddingston Loch. It is easy to forget, because of the fame of one remarkable painting, that skating never played more than a small part in the life of the skating minister.

In the summer of 1784, Robert Walker was called to the vacancy of senior minister at the Canongate Kirk, a wonderfully Baroque building on

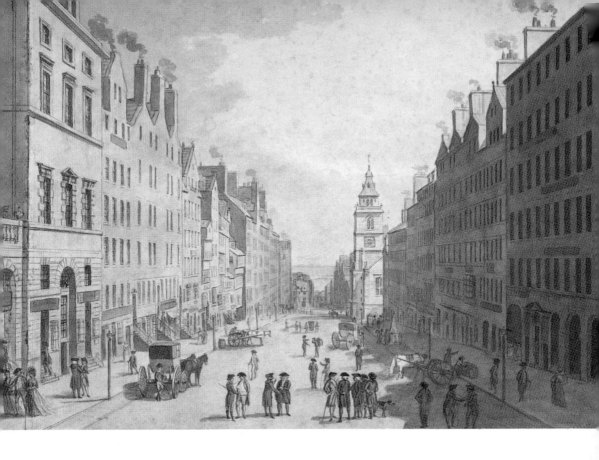

DAVID ALLAN The High Street of Edinburgh, looking East
National Gallery of Scotland, Edinburgh

This hand-coloured print, made about 1790, shows the long slope of the High Street down to the distant Canongate.

overleaf Plan of the City, Castle, and Suburbs of Edinburgh, 1798
National Gallery of Scotland, Edinburgh

This plan contrasts the irregular streets and closes of the medieval city with the ordered layout of the New Town – still thought of as a 'suburb' at this time.

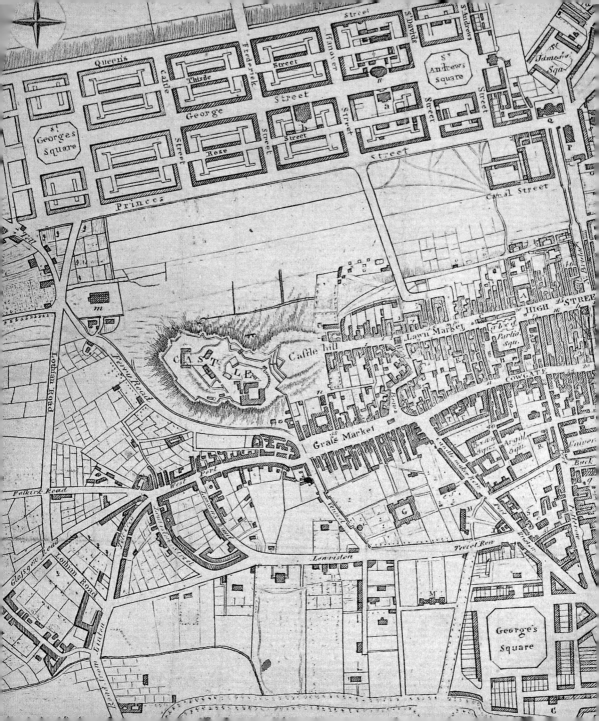

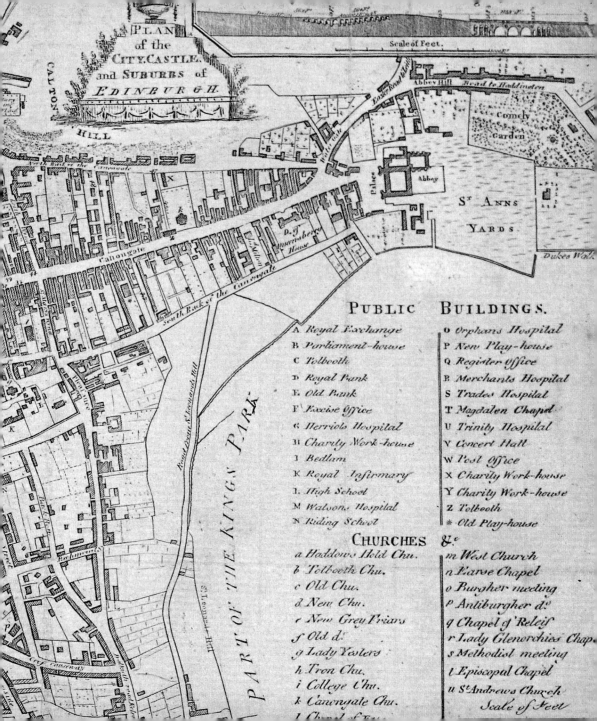

PLAN of the CITY, CASTLE, and SUBURBS of EDINBURGH.

Scale of Feet.

CALTON HILL

Road to Haddington

Abbey Hill

Comedy Garden

Water Gate

Palace

Abbey

St ANNS YARDS

Dukes Walk

North Back of the Canongate

Canongate

D. of Queensberrys House

South Back of the Canongate

Road from St Leonards Hill

St Leonards Hill

PART OF THE KINGS PARK

PUBLIC BUILDINGS.

A Royal Exchange
B Parliament-house
C Tolbooth
D Royal Bank
E Old Bank
F Excise Office
G Herriots Hospital
H Charity Work-house
I Bedlam
K Royal Infirmary
L High School
M Watsons Hospital
N Riding School

O Orphans Hospital
P New Play-house
Q Register Office
R Merchants Hospital
S Trades Hospital
T Magdalen Chapel
U Trinity Hospital
V Concert Hall
W Post Office
X Charity Work-house
Y Charity Work-house
Z Tolbooth
* Old Play-house

CHURCHES &c.

a Haddows Hold Chu.
b Tolbooth Chu.
c Old Chu.
d New Chu.
e New Grey Friars
f Old d.º
g Lady Yesters
h Tron Chu.
i College Chu.
k Canongate Chu.
l Chapel of E.

m West Church
n Parse Chapel
o Burgher meeting
p Antiburgher d.º
q Chapel of Releif
r Lady Glenorchies Chap.
s Methodist meeting
t Episcopal Chapel
u St Andrews Church
Scale of Feet

the north side of the Canongate. The charge carried a stipend of £99 a year, with, in addition, '51 bolls of victual in equal proportion of wheat, barley and oats'. It was in the presentation of the Crown, and the appointment required the assent of George III. Robert was thus, at the early age of twenty-nine, taking up a highly prestigious position – and following, as it happened, in the footsteps of his grandfather who had been minister there forty years earlier.

Robert and his wife Jean, who now had three children, Magdalen, Jane and baby John, are unlikely to have lived in the church's manse in Reid's Court, set back from the roadway a few yards down the hill; this seems at the time to have been occupied by the second minister, the Reverend John McFarlan, a landed gentleman with a large family. It is probable that they moved into a house in nearby St John's Street, composed of new and comfortable houses, one of which became the principal manse in 1816.

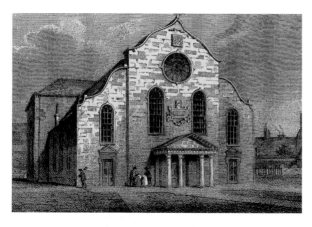

J. & H. S. STORER The Canongate Kirk
Crown Copyright: RCAHMS

A few yards from the lower end of St John's Street was St John's Hill and here Robert had as a neighbour one of the most interesting men of the time. James Hutton, now regarded as the founding father of modern geology, had lived there since 1770 and had carried out some of his early investigations on Salisbury Crags, the fantastic red stones of which

24

were thrust up just a few hundred yards from the Canongate, curving round the volcanic plug of Arthur's Seat towards Duddingston Loch. At this very time Hutton was working on his theory of the earth, which he would present to the Royal Society of Edinburgh in 1785 (Robert had been elected a literature class member of the Royal Society the previous year). Because of illness, the first part of Hutton's paper had actually been read to the

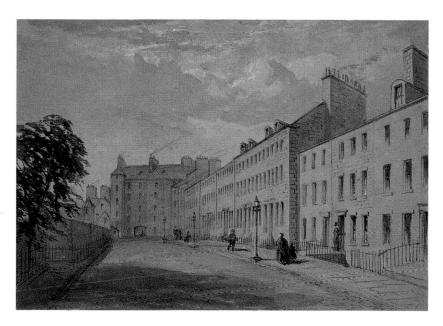

UNKNOWN ARTIST St John's Street, Edinburgh
National Gallery of Scotland, Edinburgh

Robert Walker and his family probably lived in this street when they first came to Edinburgh. The view in this modest watercolour is towards the close that leads into the Canongate, near Robert's church. The houses on the right side of the street no longer exist.

society by the chemist, Joseph Black, who had made the fundamental discoveries of carbon dioxide and latent heat. One of Hutton's central conclusions was that, 'with respect to human observation, this world has neither a beginning nor an end'. Although Hutton held to the belief that the universe was purposeful, these unnerving words were difficult for the Church to swallow. What Robert thought of them we do not know.

Mention of names like Hutton and Black are a reminder that Robert had come to live in Edinburgh at a time of enormous intellectual ferment, usually called the Scottish Enlightenment. To call this quite small city 'the Athens of the North' was not simply to refer to the shining classical buildings rising to the north of the ancient castle, but to suggest something of the values in philosophy, history, the physical and social sciences, and literature that were being propounded by a group of quite remarkable thinkers. When he visited Edinburgh in the 1770s, the English gentleman 'Mr Amyat' summed it up in this way: 'Here I stand at what is called the *Cross of Edinburgh*, and can, in a few minutes, take fifty men of genius and learning by the hand.'

While Robert was quite an adept theologian, and his sermons sometimes have a nice turn of phrase, he was part of the atmosphere rather than the substance. While making no great contribution to intellectual progress, he must have rubbed shoulders and had practical dealings with many of these geniuses. He was elected, as we have seen, to the Royal Society of Edinburgh in 1784 and was chaplain to the Edinburgh Chamber of Commerce from 1794 to 1807. He was also a member of the Speculative Society whose members included men like David Hume and Walter Scott. Hume had died four years before Robert came up to Edinburgh and his scepticism would have made him suspect to even a humane and moderate churchman. On the other hand, the homely values of Scott would have been nearer to Robert's heart.

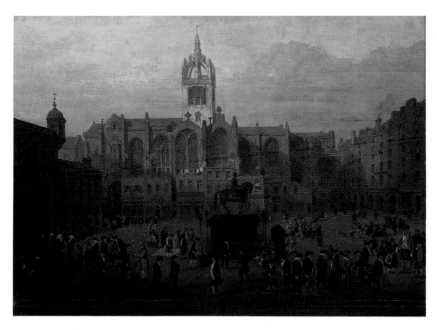

The Parliament Close and Public Characters of Edinburgh
City Art Centre, Edinburgh

*This painting was made in 1844 by a number of artists, including David Roberts. It cele-
brates Edinburgh's 'men of genius'. The figures in the painting are derived from John
Kay's etchings. The south side of St Giles is shown before the removal of the luckenbooths.*

One of his parishioners was Adam Smith, author of the seminal *Wealth
of Nations*. He lived at Panmure House in the Canongate and when he died
in 1790 he was buried in the Canongate Kirk's graveyard. It has to be
assumed that Walker officiated at his interment. Also lying in that same
graveyard were the remains of the young poet Robert Fergusson, and in
1787 Robert Burns, who saw Fergusson as his forerunner, had sought

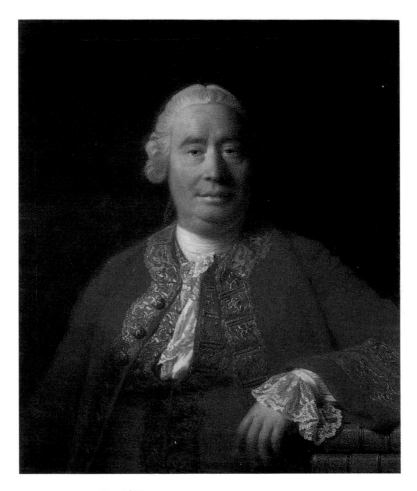

ALLAN RAMSAY David Hume
Scottish National Portrait Gallery, Edinburgh

The greatest philosopher of the age.

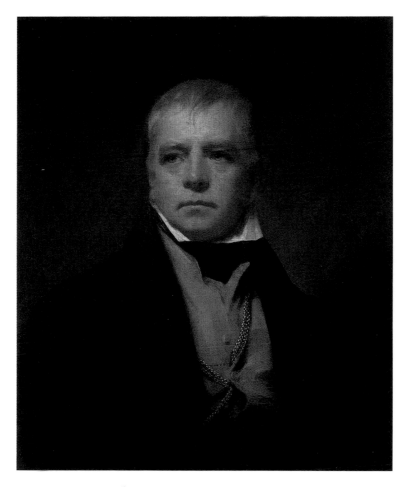

HENRY RAEBURN Walter Scott
Scottish National Portrait Gallery, Edinburgh

His literary career began with The Border Minstrelsy *in 1802.*
This portrait was painted at the height of his fame.

permission from the church session to erect a monument over his grave. Burns and Walker were close in age and their birthplaces in Ayrshire, Alloway and Monkton, were only a few miles apart – a tenuous bond but the

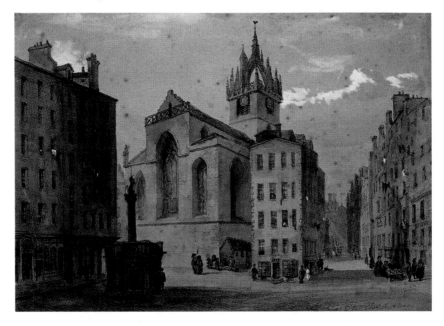

HENRY DUGUID St Giles, Creech's Land and the Cross of Edinburgh
National Gallery of Scotland, Edinburgh
William Creech ran his publishing business from this odd-looking tenement. It was a meeting place for the Edinburgh 'literati'. The building was demolished in 1817.

right HENRY RAEBURN William Creech
Scottish National Portrait Gallery, Edinburgh
Creech was a link between Raeburn, Walker and Burns.

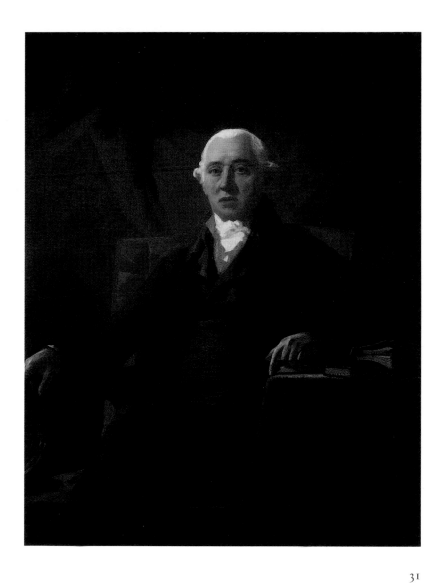

kind of thing that often draws strangers together. However, there was a stronger link. Burns was in Edinburgh to see the second edition of his poems published by William Creech, a man who was not the most generous of publishers, but whose premises were a meeting place for literary society. Creech was also Walker's publisher, bringing out his *Sermons* in 1791, and a friendship between the two is suggested by the fact that he was to be an executor of the minister's will.

Another character in this circle was William Smellie, the printer of Creech's edition of Burns's poems. It was Smellie who had not only printed the three-volume first edition of the *Encyclopaedia Britannica*, but also written a good deal of it. Such learned versatility gives the flavour of the times. Burns described Smellie as 'that old veteran in genius, wit and bawdry'.

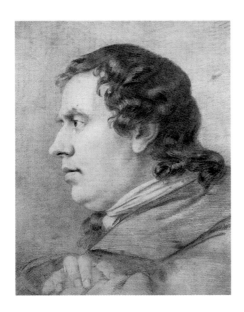

left JOHN BROWN William Smellie
National Museums of Scotland, Edinburgh

A drawing of the printer, writer and antiquary. He printed Burns's poems for Creech.

right JOHN BEUGO Robert Burns
Although this etching was taken from the famous Nasmyth portrait, Burns sat a number of times for the artist. It was the frontispiece to Creech's Edinburgh edition of the poems.

We can only guess how Walker might have reacted to Smellie's wit, but that the minister was not too straight-laced can be gathered from the remarks in one of his sermons that

> *Too many of those who make profession of religion … indulge themselves in a bitter censorius disputation, more allied to peevishness than either to virtue or religion … their conversation is gloomy, their countenances and manners forbidding. From such unfortunate examples, it is too often rashly concluded, that the nature of religion itself is harsh, melancholy, and severe.*

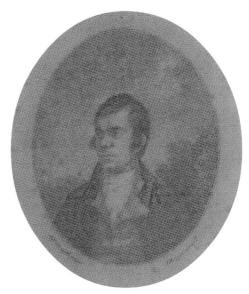

It all suggests someone who enjoyed laughter in good company.

Robert is also likely to have known the elderly Hugh Blair who had been second minister in the Canongate Kirk in the 1740s – Jacobite days that must have seemed far distant. Blair had later moved up the hill to St Giles, where he held a joint ministry with Robert's uncle, also Robert Walker. In addition, Hugh Blair was professor of Rhetoric and Belles Lettres at the University of Edinburgh, and through his close reading of texts he has come to be regarded as the founder of English literary criticism. He was also one of the Edinburgh 'literati' who encouraged Burns. The poet, in

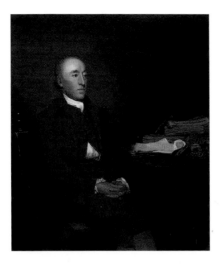

HENRY RAEBURN
James Hutton
Scottish National Portrait Gallery, Edinburgh

A neighbour of Robert Walker, Hutton's geological theories upset biblical notions of time.

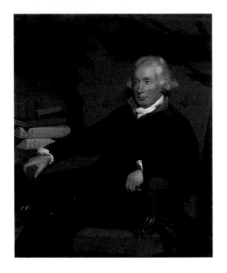

HENRY RAEBURN
Professor Adam Ferguson
The University of Edinburgh

A historian and moral philosopher, Ferguson went to Philadelphia in 1778 to negotiate with the British colonists. His Essay on Civil Society *was translated into many languages.*

gratitude, gave him a copy of John Beugo's famous engraved portrait – made specially for Creech's Edinburgh edition of the poems. Another member of Blair's charmed circle was William Robertson, principal of the university and author of one of the earliest, and still readable, histories of Spain. Horace Walpole had been amazed at the clarity of his English prose – though he could not understand a word of his accent. Robertson had been a founding member of the Speculative Society with Hume and the painter, Allan Ramsay, and it was he who commissioned Scotland's greatest architect, Robert Adam, to produce designs for the new college of Edinburgh, which was begun in 1789. Robertson was also close to Adam Ferguson, professor of Moral Philosophy at the university, a man who had once negotiated with the American rebels. It was in his house, The Sciennes, that the young Walter Scott had set eyes in wonder on Robert Burns, their only meeting. Ferguson's *Essay on Civil Society*, translated into many languages, was a hugely influential book throughout Europe.

Such men of genius were part of the everyday society in which Robert Walker spent his life. It was a society which we are fortunate to be able to glimpse through the eyes of Henry Raeburn, for of this group he painted Hutton, Blair, Ferguson and Robertson, all of them during his most creative period, the mid-1790s – the same period in which he painted his very different portrait of Walker. In the direct and expressive way in which his art defined the people who composed this society, Raeburn – and this should never be forgotten – himself became one of the great luminaries of the Scottish Enlightenment.

These were momentous times in the life of the human spirit. In the previous decade David Hume had written, 'I believe this is the historical Age and this the historical Nation.' There was little, however, that was momentous in the outward events of Robert Walker's life. Social clubs and

societies, card parties and dinner parties, archery, golf and skating (occasionally), as well as the preparation of sermons, can be assumed to be part and parcel of uneventful days – uneventful but regulated. According to the *Statistical Account*, 'People of fashion and of the middle rank dined at 4 or 5 o'clock. No business was done in the afternoon, dinner of itself having become a very serious business.' Cards and then a late supper usually followed.

The records of the Wagering Club which Robert had joined while still at Cramond contain a rare description of an actual event in his life – slight, full of merriment, and perhaps prescient of difficult times ahead. The purpose of the club was 'to keep up an acquaintance and promote mirth and good fellowship. The bets laid shall not exceed the value of one bottle of wine or half a mutchkin of punch for each person wagering.' Just before Robert moved to his new charge, the bet was 'that Robert Walker, minister of Cramond, shall repent of his accepting a presentation to the Church of Canongate before 20th January 1785'. It is a scene which gives the lie to the myth of grim Presbyterianism – and which makes it far less surprising that such a man as Walker should be pictured skating. In the event, those who had bet that he would regret the move lost their stakes.

Yet there were reasons why he might have regretted it, for he fell into a dispute with the elders of the kirk session over the custody of the communion cups. The question was, were they safer in the minister's house or in the session house? On one occasion the elders called for the vessels and 'Mr Walker peremptorily refused to give out the cups for use.' He then relented, providing he was given a receipt saying they would be returned to him on Monday morning. It was the silly kind of dispute not uncommon in church communities. It all went into the session's minute book, which Robert interpreted as 'unmerited censure' and which he asked 'to be expunged'. It was the elders' view that 'peace … and good understanding … ought to subsist

HENRY RAEBURN
The Revd Hugh Blair
Kirk of the Canongate, Edinburgh

*Blair was one of the Edinburgh
'literati' and held a joint ministry at
St Giles with the skating minister's
uncle, also called Robert Walker.*

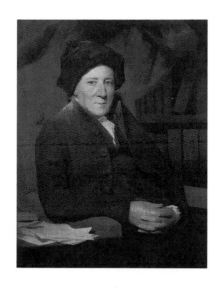

HENRY RAEBURN
Dr William Robertson
The University of Edinburgh

*Historian and founding member of the
Speculative Society. Robertson
commissioned Robert Adam to build
'the College of Edinburgh'.*

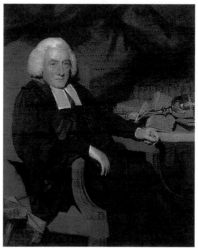

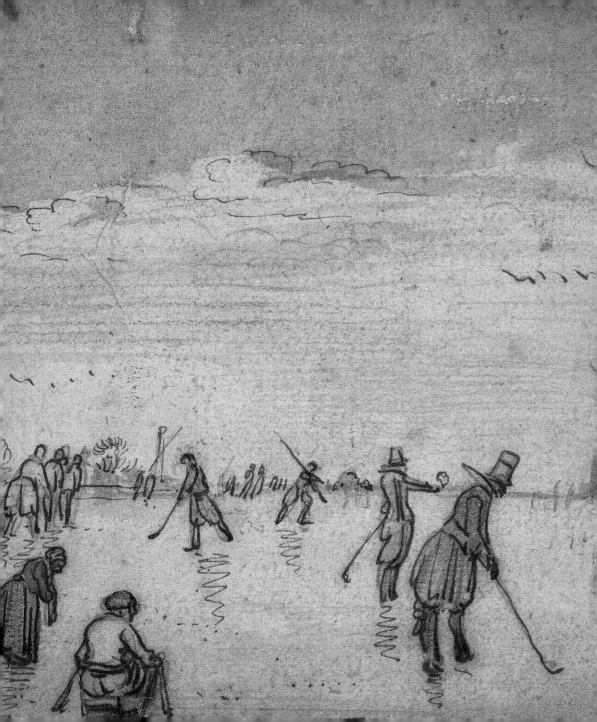

amongst the members and Mr Walker', but decided that altering the minutes would be 'not only an improper and dangerous measure, but beyond their power ...' Since the events had actually happened it seems a reasonable point of view, and the affair shows this man of the Enlightenment in a not entirely reasonable light. The matter appears to have rumbled on, but he got to keep the cups.

We would love to hear Robert's voice on skating, on Raeburn, and on his portrait, but it is a fond wish. We do, however, hear him in his writings, particularly his sermons, as we have already seen. From these we can come a little closer to his personality. In his short article on the odd Dutch game of Kolf he remarks that he himself had been 'no mean player' – no false modesty here. In his *Observations on the Dutch*, published in 1794, he is firmly pro-Dutch, though he could be accused of dealing in stereotypes:

> *The Dutch are a* steady *rather than a* speculative *people.*
> *They are not disposed to part with the substance for the shadow.*
> *The great body of the people are enthusiastically attached to*
> *every thing that relates to* Vaderland, *as they call their country*
> *... The phlegmatic disposition of the Dutch nation prevents*
> *them from being speedily roused; but there is, notwithstanding*
> *their natural slowness, an energy and firmness in their*
> *character that must ever render them formidable when once*
> *they are stimulated to action.*

This high regard for the Dutch must have carried over from his early days in Holland, but he is not uncritical. He is particularly upset by a legal system

HENDRICK AVERCAMP Winter Scene with Skaters (detail)
National Gallery of Scotland, Edinburgh

This watercolour shows players of Kolf aiming at a target post fixed in the ice.

39

that is secretive, denies representation, and uses torture, in his view 'contrary to all approved maxims of jurisprudence'. He ends his little book with a detailed essay on Dutch taxation.

From his published sermons we have already noticed his belief that religion need not be a glum business, and the 'energy and firmness' that he saw in the Dutch are qualities that mark his own Christian beliefs. Politically, the effects of the French Revolution and the Terror were in the air, as well as a fear of invasion, and this prompted two sermons on patriotism which his friend Creech published for him as separate pamphlets in 1794 and 1797. Incredulous at any notion of freedom other than the British one, he cries, 'Britons! What other liberty, what other equality would you covet? Cast your eyes … on that Government by *Revolutions*, which your enemies mean to substitute … by a war of invasion, and to perpetuate … by the permanent instrument of death.' In stirring words he reminds his listeners that although they spend their days in tranquillity, they must remember their brothers who are defending the country, those for whom 'Every gale wafts to the ears the groans of death, every stream runs red with blood.'

A gentler note can be heard when he speaks of the 'duties' of the Christian. Something that has a resonance for our own time is his belief that one of the most important of these duties is that of maintaining 'brotherly love amidst these differences of religious opinion which cannot be prevented'. He has seen that 'anger, malice, and revenge … have hurried many to their ruin … have slain their thousands …', and his firm conclusion is that 'Christianity is the Religion of LOVE'. These are Robert's capital letters.

One final passage from the sermons is worth quoting, for while it may end on a note of Calvinistic pessimism, it is a reminder that in these very years poets like William Wordsworth (who acknowledged the influence of Burns) were finding moral qualities in a freshly observed Nature. Preached

in the winter of 1789, Robert himself paints a landscape which is curiously like the one we know he skated in:

> *The glory of the summer is departed; the blast of the*
> *wilderness has passed over it, and it is gone, and*
> *winter tarnishes the beauty of nature. It is sad to see*
> *the leafless trees, the naked fields, the ruins of the*
> *year. Yet the beauty of nature shall be restored, the*
> *leaves, the bloom, and fruits, shall revive … But thy*
> *mispent youth, O man! shall never return.*

The principal collection of sixteen sermons was published by Creech in 1791, followed by an American edition in 1797. The following year Robert drew up his will, which might suggest that he felt his health to be failing, although he was still only forty-two. In his will he left all of his 'moveable goods' to his fourteen-year-old son, John. Little is known of Robert's family life in these years. He and Jean had lost their one-year-old son, William, in 1787; in 1788 another son was born and given the name Robert, perhaps to assert continuity and a resolve to go on with life whatever tribulations fate might inflict.

Robert Walker died in 1808, aged fifty-three. He was buried in the northeast corner of the Canongate graveyard, but the gravestone that must have been erected has vanished. His widow Jean lived on for many years, until 1831. How often did she glance at the rather strange portrait of her late husband? Among the nine trustees of Robert's estate were Charles, Earl of Haddington, hereditary keeper of Holyrood Park (and the man who had quarried the wonderful Crags before a public protest stopped him), William Creech the publisher – and 'Mr Henry Raeburn, Portrait Painter in Edinburgh'.

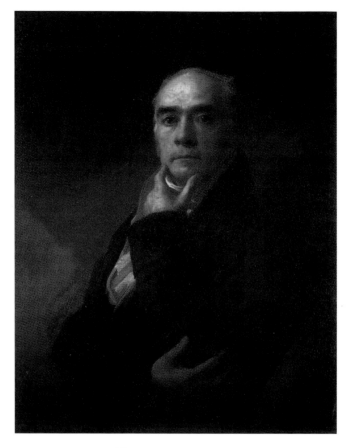

HENRY RAEBURN Self-portrait
National Gallery of Scotland, Edinburgh

*Painted in 1815 at the height of his worldly success. Raeburn
painted his friend Robert Walker at least fifteen years earlier,
when his art was at its most original.*

THE PAINTER AND THE PAINTING

HENRY RAEBURN had described himself as 'Portrait Painter in Edinburgh' from an early stage in his career. In one way the words are only descriptive, but in another sense they say a good deal about his pretensions, and these were pretensions that were quickly fulfilled. By the time he came to paint his friend Robert Walker, he was not only a 'Portrait Painter in Edinburgh', but by far the premier portrait painter in Scotland. Born in the Edinburgh village of Stockbridge in 1756, and hence just a year younger than Walker, he had started his creative life as a jeweller's apprentice and quite soon graduated to miniature painting. Although his later portraits are characterised by broad and generous brushwork, in details he was always able to call on the refined skills he had learned in his early days – skills that found full scope in the figure and foreground areas in his portrait of the skating minister.

Marriage to a wealthy widow, Ann Edgar, enabled him to set off for Italy in 1784, where he spent the best part of two years. This was a journey that most Scottish artists of any note felt they had to make and Raeburn, despite his quite recent marriage and the birth of two children, must have seen it as a necessary prelude to his intended career as a portrait painter. Not much is known about his activities in Italy, but one thing he learned from the Italian Baroque painters was how important the movement of light is within a painting. This is clear from many of the portraits he painted during the

43

1790s, the most creative and original phase of his life. When he exhibited his early masterpiece, the double portrait of Sir John and Lady Clerk of Penicuik, in London in 1792, his use of deep shadows lit on their edges by dazzlingly bright light caused the critics to raise their eyebrows. In Edinburgh, the novelist Henry Mackenzie (the man who had dubbed Robert Burns 'this heaven-taught ploughman') called this way of painting, disapprovingly, Raeburn's 'falsetto style'. By this he probably meant an untruthful, foreign style. It seems that many of Raeburn's clients also found it difficult to accept and, although the shift of light always remained an important ingredient in his painting, his later portraits became more conventional in this respect.

It was a change in style that assured his success for the remainder of his life. He contemplated moving his practice to London in 1810, but after a visit thought better of it. This was fortunate for Scotland, for we now see so much of this vibrant society through his eyes. He did, however, always regret not having the opportunity of seeing the works he sent for exhibition at the Royal Academy hanging alongside those of admired contemporaries like William Beechey and Thomas Lawrence. On one occasion he sighed that London seemed as distant 'as the Cape of Good Hope'. It was this regard for London that lay behind his self-portrait of 1815, the year in which he was elected a member of the Academy. There is little doubt that this self-portrait was meant to convey his high pretensions as a creative artist to his English counterparts. In a way, London continued to thwart him for he had painted this picture as his diploma piece without realising that portraits were not acceptable.

Otherwise, success followed success, culminating in a knighthood when George IV visited Edinburgh in 1822. However, there was one major setback in the course of his career. He had become involved in insurance

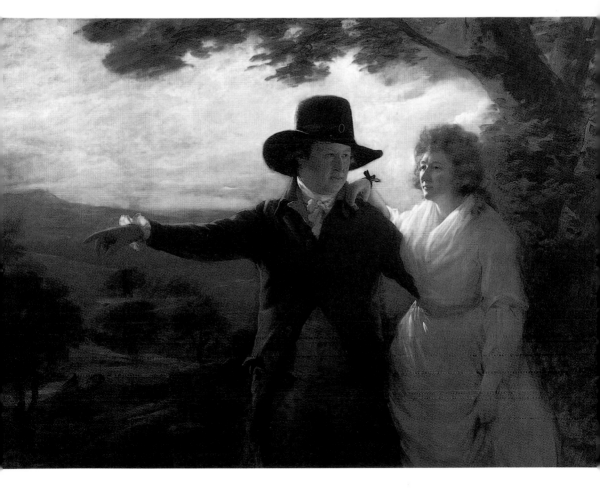

HENRY RAEBURN Sir John and Lady Clerk of Penicuik
National Gallery of Ireland, Dublin

Raeburn's early masterpiece.

broking and shipping and in 1808 he was declared insolvent, with massive debts. For the remainder of his life, in much the same way as Walter Scott would write to pay his creditors, Raeburn dedicated himself to painting his way out of debt. Though many of his greatest paintings came in these later years, some of his work shows the dangers of over-production. Also, there was now no likelihood that he would find time to indulge in a playful experiment like the portrait of Robert Walker, painted we might guess as much for Raeburn's own satisfaction as that of the skating minister.

Exactly why Raeburn made this unique portrait of his friend will probably never be known, unless some new document comes to light. That they were friends we assume from Robert Walker's will, but the clearest testimony of all is the painting itself. There is no evidence that they ever skated together, but Raeburn liked company and was a man of great vigour. It is more than likely that they at least walked round the looming Arthur's Seat in each other's company to the frozen loch at Duddingston. The intimacy that must have existed between them on such an occasion we can sense in Robert's words in another of his sermons: 'Consider the delight which is communicated to all outward objects by the presence of a friend whom we love and esteem. With such a companion, we forget all lapse of time.' Although only Robert is depicted in the picture, these sentiments convey exactly the kind of bond that united the two men. It is in this, perhaps more than anything else, that the magic of the painting lies.

Skating, when conditions allowed, had become a fashionable sport in Scotland in the latter part of the eighteenth century and the Edinburgh Skating Society, which dated back to at least the middle of the century, placed great emphasis on good fellowship and mutual admiration. Robert, however, skates alone. The 1797 edition of the *Encyclopaedia Britannica* describes the vogue in this way: 'The metropolis of Scotland has produced

more instances of elegant skaters than perhaps any other country whatever; and the institution of a skating club ... has contributed not a little to the improvement of this elegant amusement.' Raeburn was never a member of the club – he probably didn't have enough spare time for that kind of commitment – but he must certainly have seen Walker skating, and been intrigued by the sight. He must also, at the very least, have made some sort of mental record of the gliding figure, to be sorted out and elaborated later in his studio. Whether that studio was his original one in George Street or his painting room in the splendid terraced house he had had erected at 32 York Place (now a dejected looking suite of offices) in 1798, depends on the date of the painting.

Robert Walker had joined the Edinburgh Skating Society in the winter of 1780. This was fifteen years before the introduction of an entrance test which involved skating a complete circle on each foot, and then making three jumps over three hats piled consecutively on top of each other. Although these tests were introduced long after Robert joined the society, an ability to skate well was always expected of the membership. This consisted mainly of lawyers and landed gentlemen, with a number of army officers, a few merchants, civil servants and medical doctors – and three ministers. It is not clear what form of skating the society favoured in these early years but, although it was a sociable affair, it had not reached the elaborate combination styles of the nineteenth century. The society's motto, engraved on the medal each skater was expected to wear suspended from a ribbon round his neck, was 'Ocior Euro'

above The reverse side of an Edinburgh Skating Society badge, 1782
National Museums of Scotland, Edinburgh

– swifter than the east wind – a quotation from the Latin poet Horace, but highly appropriate for Edinburgh weather. That Raeburn has shown Robert without the society's badge suggests that he was not particularly familiar with the rules of the society.

The motto hints that speed was a significant aspect of the kind of skating practised by the society. Another was the performing of a series of 'attitudes and graces'. Many of them had been described by an artillery officer, Robert Jones, in the first text book on skating, the grandly titled *Treatise on Skating*, published in London in 1772. Among these attitudes was the so-called 'Flying Mercury', illustrated in an engraving in Jones's book. It was a pose that imitated a famous piece of sixteenth-century sculpture, the bronze *Mercury* by Giovanni Bologna. A version of this was engraved on some of the members' medals. The illustration in Jones's book, although the skater's arms make elegant gestures, shows the head in pure profile, the body taut, and recalls Raeburn's portrait in a number of ways.

Jones also describes a 'Fencing Position' and a 'Salutation'. In the latter, two skaters approach each other, bow, remove their hats, replace them and turn away. These were moves which the Edinburgh society may well have practised. However, probably more indicative of the Scottish experience was the article on skating in the *Encyclopaedia Britannica*, which describes an attitude of 'drawing the bow and arrow while the skater is making a large circle'. Another attitude consisted of military salutes (war, after all, was on everyone's mind) which were said to have 'a pretty effect when used by an expert skater'. We might speculate that Robert would have considered the archery attitude too much of a parody of the real skills he had to show as a member of the Royal Company of Archers, and that the fancy gestures were really too frivolous. But perhaps he was game for anything. At any rate, he chose – or was it Raeburn's choice? – to be portrayed propelling

himself forward in the conven-
tional 'Travelling Position', his
arms folded compactly on his breast.

While Raeburn's skating portrait is
unique in its scale and quality, other con-
temporary portraits of skaters in both Eng-
land and France were not unknown. However,
the only one he might just have seen was Gilbert
Stuart's *William Grant of Congalton*, which had
been a great hit at the Royal Academy in 1782.
There are a few similarities: in each a black
attired gentleman, arms folded, skates on a large
stretch of ice, rapt in thought. These features
could have been enough to spark a thought
in Raeburn's mind, but little more, for the
differences are considerable. For example, the
portrait of Grant is life-size and the figure is al-
most frontal. Grant also skates with others,
though they are reduced to small figures in the dis-
tance, and spectators watch from the bank. Further,
that Grant skates in London's St James's Park is
emphasised by the inclusion of the easily recognisable
buildings of Whitehall in the distance.

The Flying Mercury
British Library, London

*This engraving of a skating 'attitude' was published in
Robert Jones's* Treatise on Skating *in 1772.*

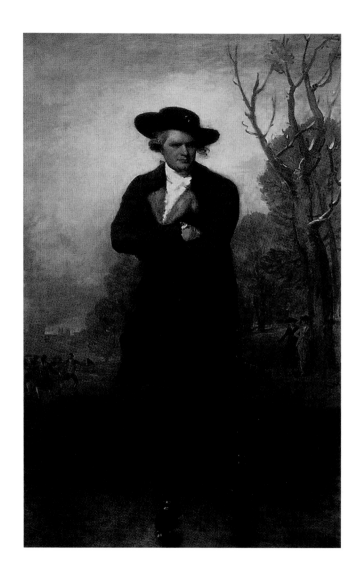

Raeburn has not been topographically accurate in this way. Indeed, doubts as to whether Robert should be described as skating on Duddingston Loch have been raised from time to time, but the traditional title is certainly an appropriate one. Although Raeburn generally believed that landscape backgrounds should not be too detailed, in this case he has been at pains to convey the feeling of an actual locality. He has done this by loosely combining the two landscape features most likely to have left a lasting impression in the minds of those who walked out from Edinburgh to the village of Duddingston to skate on its loch: the towering form of the Nether Hill (or Lion's Haunch) of Arthur's Seat on their left as they approached the village, and the distant, snow-tipped Pentland Hills to the south as they are seen from the surface of the ice.

It is, however, the finely modulated, dark outline of Robert Walker's figure against the icy greys of the foreground and the slight pink of the landscape and the gathering dark of the clouds in the distance, that make the portrait so striking and memorable. The same delicate precision that has traced the figure's outline also marks the warm profile of his face, the flecks of paint so deftly placed that we are convinced that this is exactly how the man must have looked. Although the hazy background is brushed with the easy freedom we have come to expect from Raeburn, the lower part of the picture shows that fine skill in portraying the minutest details that Raeburn always retained. For example, there is the filigree of the buckle on the garter at Robert's right knee and, again, the amazing complexities of the bindings that fix the skates to his shoes. Two materials are used here, subtly

GILBERT STUART William Grant of Congalton
National Gallery of Art, Washington / Bridgeman Art Library
This painting was exhibited in London in 1782.

51

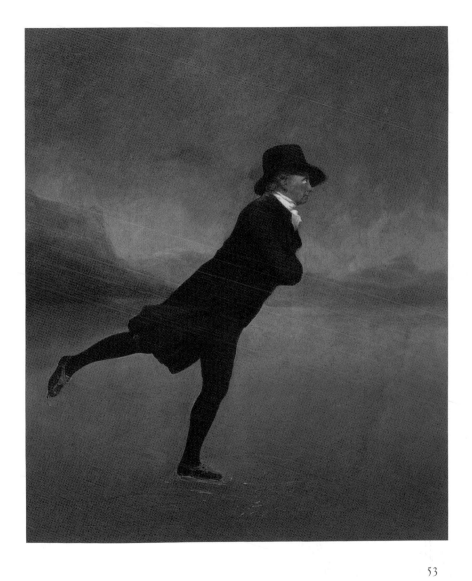

53

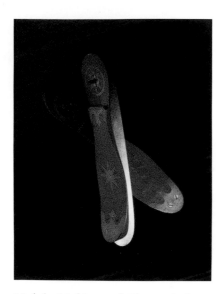

differentiated in texture and colour. Each skate is attached to the shoe by its three brownish leather straps, one at the heel, one across the instep and the other at the toe. These straps have then been tensioned by a pink linen tape ('inkle' is the technical term) whose windings and knots are perfectly detailed.

This subtlety of description is continued in the receding sheet of ice itself, which accounts for virtually half the picture area. Its hardness seems to echo with the sounds of those who are no longer there, but who have left the traces of their presence on the scored surface. Here Raeburn virtually repeats with his painting tools the very action of Robert's steel blades, and of those who have skated there before him. Over a layer of dark grey paint which has been allowed to dry, another layer, this time of liquid greyish white, has been spread and before that has dried he has

Made by Mathieson of Glasgow in the nineteenth century, the principal attachment of these skates was by a screw into the heel of the skater's shoe. Robert Walker's skates, however, appear to be held in place by a clamp.

National Museums of Scotland, Edinburgh

scored it with a series of curved lines, probably made with the handle end of a sable brush. This reveals the darker grey beneath, which thus represents the scores made by the skates on the ice. When the second, or top, layer has dried, and especially towards the bottom of the picture where the grooves are more pronounced, he has tipped their edges with a purer white to suggest the froth of ice thrown up by the pressure of the blades. Yet it is all detail that blends easily with the broader brushwork in the upper half of the painting,

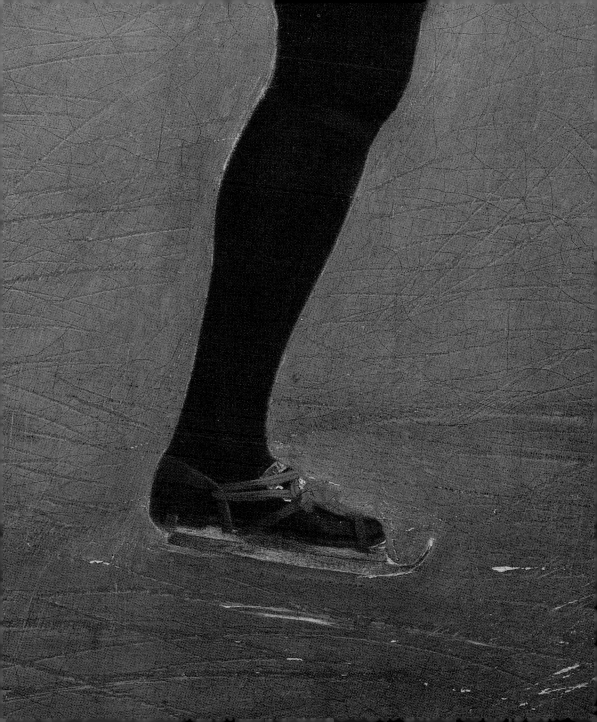

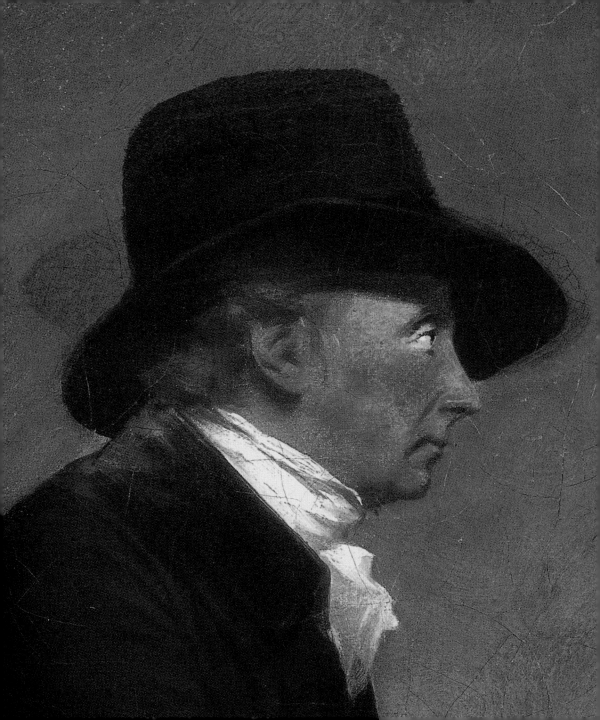

perfectly balanced visually, as the skater himself is perfectly balanced.

One aspect of the refining and correcting which underpins the lucid perfection of the finished picture has given rise to some unfounded myth-making. That is the now very visible change that Raeburn made to the position of the wide-brimmed hat, which casts a tiny shadow onto Robert's forehead. This alteration would have been made as the painting developed and would not have been visible when it was completed. However, oil paint has a tendency to become transparent with time and so the change of mind can be seen once more. Interesting as it is in showing how Raeburn's mind worked, it gave rise to the notion among Robert's descendants that Raeburn had altered this part of the picture many years after he had painted it so that it matched Robert's appearance at the time of his death. However, there is not the slightest sign of a change of that sort.

Portraits in profile were common in the early years of the Italian Renaissance, but they nearly always took the form of simple head and shoulders. Apart from on coins, where profiles were always the norm, they became less common in succeeding centuries. There was, however, a certain vogue for them in the more modest reaches of English society portraiture in the eighteenth century. What we now call silhouettes were also becoming popular, the profile of the subject traced from an actual shadow before being reduced to miniature size. During the 1790s Raeburn became intrigued by the profile head as an aspect of his experiments with how the illumination of the head and its outline could be related in an expressive way to the degree of dark or light in the background. These effects which so interested him are called *contre-jour*, 'against the light'. He did not invent the form but he gave it a unique charge. The most notable examples are the portrait of William Glendonwyn in Cambridge and the double portrait known as *The Archers* in the National Gallery in London. The latter also has a tense dynamic and a

geometry which is of the same kind as the painting of the skating minister.

Was Raeburn's image of the skating minister a wholly original invention, or was it suggested by the work of some other artist? Such promptings are commonplace in all of the arts and a great work can be built, as the plays of Shakespeare demonstrate, on the foundations of something far inferior.

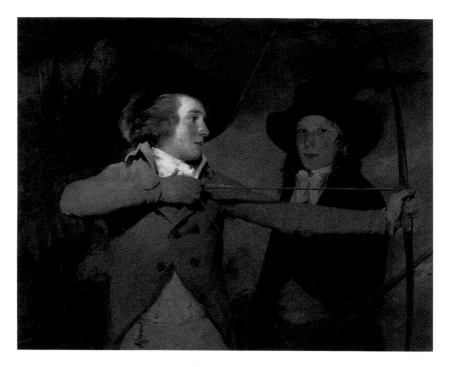

HENRY RAEBURN Robert and Ronald Ferguson (The Archers)
National Gallery, London

Archery became a popular social pastime in the second half of the eighteenth century. In 1779 Robert Walker joined the Royal Company of Archers.

Raeburn must have been familiar with the little etched portraits of the Edinburgh caricaturist John Kay which were lively and humorous but entirely unsophisticated. A large number of these etchings show well-known figures of the city perambulating through its streets – full-length, with both body and head in profile. They prompt the question: did Raeburn take the example of Kay's etchings and move them onto a different artistic plane? There is an especially witty one, set in the countryside, that illustrates a hilarious episode in the life of William Forbes of Callendar. Dated 1797, and unusually animated, it shows the rich entrepreneur fleeing in disarray from his imagined enemies, his Falkirk neighbours who disapproved of his wealth. But the flames that cause him to leap, in a way that is so reminiscent of the skating minister's posture, were in fact spouting from the nearby Car-

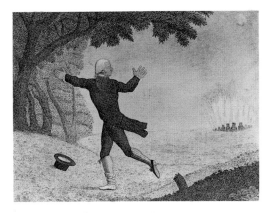

JOHN KAY William Forbes of Callendar
Scottish National Portrait Gallery, Edinburgh

Kay's naive etchings may have influenced Raeburn.

ron blast furnaces. Did Raeburn take a quick look at this naive, but amusing, print and note its possibilities? It so happens that Raeburn painted a very grand portrait of Forbes the following year, 1798. Forbes is hardly likely to have produced Kay's print for inspection when he came to Raeburn's studio, but the painter is more than likely to have been aware of it as he worked on the portrait of his vainglorious sitter. If there is a grain of truth in the notion that Raeburn was influenced by this little print, it could mean that the portrait was painted in 1798, or even a little later. This would

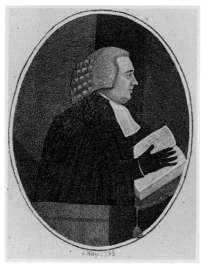

JOHN KAY
The Reverend Robert Walker
Scottish National Portrait Gallery,
Edinburgh

*This is the skating minister's uncle,
one of the two ministers of St Giles.*

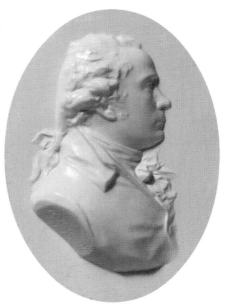

HENRY RAEBURN Self-portrait
Scottish National Portrait Gallery,
Edinburgh

*This little self-portrait, probably cast
for Raeburn by James Tassie, is likely
to have been made as an experiment.
It may have influenced his portrait
of Robert Walker.*

make Robert about forty-five at the time and solve a problem that has bothered many – the fact that he seems too old for a portrait of the early 1790s when he would still not have reached the age of forty.

It is also worth remarking that Robert Walker himself must certainly have been aware of Kay's little portraits, for one of them depicted his uncle Robert in the act of preaching in St Giles. It is dated 1793 and it too is in profile, and one that is not unlike the younger Robert's. Is it at all possible that Raeburn and Robert looked at this together and conceived the painting as a kind of amusing reprise of the simple etching of the other, and, at the time, much more famous, Robert Walker?

However, the one experiment in profile which comes closest to the portrait of Robert Walker, and it is a performance just as unexpected, is the little cameo portrait Raeburn made of himself in 1792. Raeburn is known to have contemplated becoming a sculptor, but this is his only work in three dimensions. It is likely to have been modelled as a *jeu d'esprit*, a little competitive game, with that other great portraitist of the Scottish Enlightenment, James Tassie, during one of his modelling visits to Scotland. Tassie is, of course, the supreme profile portraitist of the period (he made the only known portrait of Adam Smith) and we can guess that Raeburn was so intrigued by his workmanship that he was tempted to try his hand, using himself as the subject. The wax model he made would then have been cast by Tassie in his opaque glass paste on his return to London. The result was another unique portrait, where the touch of the modelling tool, not finicky but subtle and refined, is so close to the crisp brushstrokes that describe the outline of Robert's face, the merging of his ear and hair, and the stock that enfolds his throat.

One modelled and one painted, these two portraits have a perfect, matching artistry. In the medallion Raeburn gazes at himself gazing at the world

with firm assurance. In the painting he contemplates his skating friend just as intently, but with perhaps a smile starting to light up his face. Now, as we contemplate them both we can easily begin to sense the affection that united them. Since a number of casts of the self-portrait are likely to have been made as gifts, it is fair to speculate that Raeburn might have given one to Robert as a private token of their friendship – a friendship that would lead in a year or two to the painting of a portrait that would one day gain a surprising, and spectacular, fame.

Henry Raeburn, the painter, and Robert Walker, the minister, would no doubt be amazed at these attempts to work out the story behind this painting – for they knew the truth! However, the one truth we are sure of is that, with an intimacy rare in portrait painting, they have left for our enjoyment a picture of wit and beauty that, while it intrigues, expresses a well-being of the spirit. The Reverend Robert Walker's resting place in the Canongate kirkyard may have vanished, but he skates on in grace, as if he were still with us.

SOURCES

Margaret Elliot, 'The Edinburgh Skating Club 1778–1966', *The Book of the Old Edinburgh Club*, vol. XXXIII, part 2, Edinburgh 1971

Ian Hay, *The Royal Company of Archers 1676–1951*, Edinburgh and London 1951

Robert Jones, *Treatise on Skating*, London 1772

Jean Morrison, *Scot on the Dijk. The Story of the Scots Church, Rotterdam*, Kirkpatrick Durham 1981

Hew Scott, *Fasti Ecclesiae Scoticanae*, Edinburgh 1915–

Sir John Sinclair (ed.), *Statistical Account of Scotland*, Edinburgh 1791–9

William Steven, *The History of the Scottish Church, Rotterdam*, London and Edinburgh 1832

Robert Walker, *Sermons*, Edinburgh 1791

Robert Walker, *The Psalms of David Methodized*, Edinburgh 1794

Robert Walker, *Observations on the National Character of the Dutch, and the Family Character of the House of Orange*, Edinburgh 1794

Robert Walker, *The Sentiments and Conduct becoming Britons in the Present Conjuncture*, Edinburgh 1794

Robert Walker, *A Sermon preached on the Occasion of the General Fast*, Edinburgh 1797

Kirk Session Minutes: Cramond CH2/429/9; Canongate Kirk CH2/122/14 and 15 (Church of Scotland and National Archives Scotland)

Parochial Registers, Canongate 685 3/24 (National Archives of Scotland)

Register of Deeds RD 3/327 (National Archives of Scotland)

PHOTOGRAPHIC CREDITS

Douglas Clapperton: p.33

Keith Hunter Photography: p.8

Heidi Kosaniuk: p.22–3

Jack Mackenzie, AIC Photographic Services: p.34 (top), p.37 (top), p.42, p.58, p.60 (bottom)

Antonia Reeve; p.6, p.25, pp.27–31, p.38, pp.52–3, pp.55–6, pp.59–60 (top)

Joe Rock: p.34 (bottom), p.37 (bottom)

Thanks to John Burnett, Principal Curator of the Scottish Modern History Department of Scotland and Europe, who has provided valuable information on aspects of sporting activities in Scotland